Sister Wendy's Book of Muses

Sister Wendy's

Book of Muses

with photographs by Justin Pumfrey

Harry N. Abrams, Inc., Publishers

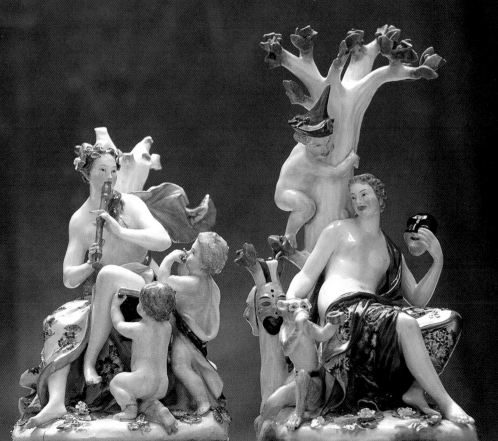

Dedication

For Hugh Davies, Yvonne Adams, Zelli, the Cories, the Haughtons,
and all who have helped me appreciate porcelain.

Editor: Katherine Rangoon Doyle
Designer: Carol Robson

Library of Congress Cataloging-in-Publication Data
Beckett, Wendy
 Sister Wendy's book of Muses / by Wendy Beckett.
 p. cm.
 Includes bibliographical references.
 ISBN 0-8109-4388-3 (hardcover)
1. Porcelain figures—Europe—History—18th century. 2. Muses (Greek deities) in art.
3. Porcelain figures—Private collections. I. Title: Book of Muses. II. Title.
 NK4373.B43 1999
 738.8 ' 2 — dc21

Harry N. Abrams, Inc.
100 Fifth Avenue
New York, N.Y. 10011
www.abramsbooks.com

J. J. Kändler. *Euterpe* (detail).
c. 1745. Porcelain, 8⅝" (22 cm).
Private collection

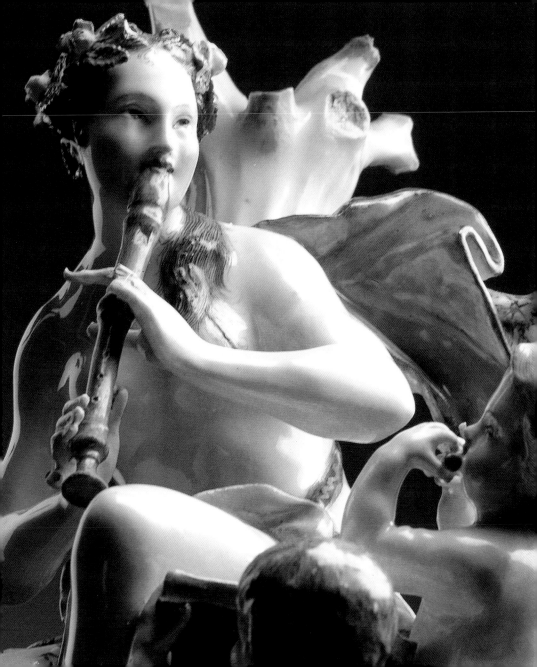

J. J. Kändler. *Polyhymnia* (detail). c. 1745. Porcelain, 10¼" (26 cm). Private collection

You are writing a novel or a poem or even a letter; you are composing music or you have to give a speech; you want the right answer for an unexpected question. What you are looking for, of course, is inspiration, and if you had lived in ancient Greece or Rome you would have known immediately how to obtain it. You would have lifted your head and called upon the Muses. The Muses were inspiration personified. They were the daughters of the Greek god Zeus, the king of the gods (or his Roman counterpart, Jupiter or Jove), and Mnemosyne, goddess of memory. The sudden awareness of how to write or say something seems to come, paradoxically, from the outside, hence the belief that inspiration is not our own, but a response from the Muses. The Muses' father, Zeus, gave them access to power, to the unexpected, and to that which we cannot control. Zeus was famous for his great storms, hurling thunderbolts

and dazzling the world with his lightning, and his daughters share that interest in spectacle. But they also share their mother's more introspective nature. Our memories make us what we are. Lightning can set a field on fire only if grass is growing there, and what the Muses do is to illuminate the parts of ourselves that we are not always conscious or aware of—our memories. Inspiration comes from within and yet seems to come from without. The Muses are an embodiment of this strange and magical interplay.

The Muses are airy creatures, nine beautiful young women dancing and singing in their mountain home. The Greeks knew that these heavenly nymphs could never live ordinary lives on earth, at a mortal's lowly level, but they could never actually agree on where the Muses did reside. Was it Mount Olympus, where all the other gods lived? Or was it Mount Parnassus, one of the many other mountains that figure in mythology? Something about the way inspiration works suggests a stream, and there *was* a famous stream on Mount Parnassus that was closely associated with Apollo and the Muses. Though no mortal had ever actually seen it, the Castalian spring of crystal waters was said to have the power to give inspiration. And then there was also Mount Helicon, sacred to the Muses alone, inspiration being an essentially private business. This, too, had its fount, the even more famous Hippocrene, which sprang into being when the great hooves of Pegasus, the winged horse, struck the mountain meadow.

When the poet John Keats spoke of his longing for "a beaker full of the warm South, / Full of the true, the blushful Hippocrene," ❦[1] he suggested that this fount flowed with wine, not water: and that, too, is right for the Muses. Inspiration in the noblest sense can be an intoxicant, and the Muses were always friendly with Bacchus, the god of wine. But they were never too friendly. There are, in fact, hardly any stories attached to the Muses. Their lives revolved around Apollo, god of sunlight and poetry, who acted as their conductor, and the myths are full of his adventures. But the Muses themselves remained sedately in their cloud-covered heights, now and again acting as a lamenting chorus for a hero's death, rejoicing in a royal marriage, or even judging a musical contest. Their life consisted of waiting, patiently and happily, for a call upon their services from the earth. In *Henry V,* when Shakespeare really wants to outdo himself, he calls for "a Muse of fire" that will bear him up to "the brightest heaven of invention." ❦[2] That was what the Muses were for: to take you where you felt you could not go merely on your own steam.

The Muses elude us as individuals. We know of nine, and they all have names and different functions—one Muse for each separate sphere of influence in learning and the arts. They are just as often collectively referred to as "The Muse." Possibly the last great writer to whom the Muses were in any sense real was John Milton, yet when he calls, "Sing, heavenly Muse," ❦[3] he is clearly not only thinking of Urania, the Muse of astronomy,

whose name means "heavenly." He is thinking of Inspiration itself, "The Muse." This presents a challenge for anyone wishing to depict the Muses individually. Artists have often tried, but however lovely, the Muses suggest little to the painter in the way of narrative. They sing, they dance, they sit or lie on the grassy summit of their faraway mountain—not exactly gripping material. The sculptor has an even harder task, trying to hone in on the nature of goddesses whose personality is, for all intents and purposes, impersonal. The Getty Museum in Los Angeles, California, has a charming Roman marble entitled *Muse,* but it could be any Muse, or any nymph or young woman. Antonio Canova, the great eighteenth-century sculptor, carved several "ideal heads," and some of them have been given Muses' names. But any name seems equally apt: these heads are beautiful, remote, pensive, and perfect. Each is rather like what we imagine a Muse should be. Apollo, their leader, does well in sculptural terms, a great resurgent yet elegant deity: but his little band of singing virgins, no. Only one art medium seems capable of capturing the Muses' enchanting blend of the divine and the earthly, their near corporeality (their essence, after all, is functional), and that is ceramics.

The great porcelain factories that originated in the eighteenth century produced figurines that epitomize the height of decorative art. Power and formal beauty in a medium that is so vulnerable to time and accident: is this not perfect for the Muses? So little porcelain sculpture has survived

J. J. Kändler.
Thalia (detail).
c. 1745. Porcelain,
10⅝" (27 cm).
Private collection

intact. Toes and fingers are chipped or lost, and broken arms and legs are mended. This, too, seems just right, because the Muses, once so famous, are now merely memories, broken and nearly forgotten and yet still able to offer us inspiration. Nearly all the porcelain factories felt compelled to reproduce the Muses, and the ones I have chosen for this book are not necessarily the best, just figures that are dear to me. Each porcelain has caught, with affectionate playfulness, something of the particular Muse's nature, and yet there is a hint, in nearly every figure, of the full dimensions of that nature. One of Shakespeare's heroines says of another, "though she be but little, she is fierce." [4] The Muses were never fierce, but they never forgot that, though they were little, they were goddesses.

Calliope

The oldest of the Muses is Calliope, whose name means "beautiful voice." She is the intellectual Muse, the inspiration of epic poetry and philosophy. For us today, "epic" is merely an overused adjective, used to describe blockbuster films and novels. But for a world now forever lost to us, it had a very precise meaning. An epic, usually poetic but not completely barred to prose, was not only a long work, but one that was profoundly serious. In an epic, an author expressed his or her vision of what life was and could be. There could be humor in an epic—Homer's *Odyssey* is far from solemn—but the humor was integrated into a worldview. Homer makes us aware, through Odysseus's travels, of what it means to be human. With so much at stake, an epic may be a life's work: only Homer seems to have composed two, prefacing the adventures of the *Odyssey* with the tragedy of the *Iliad.*

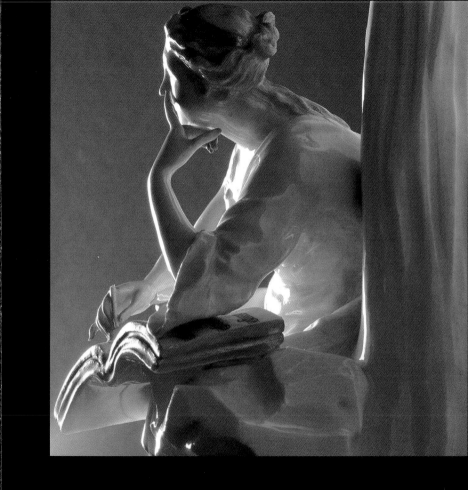

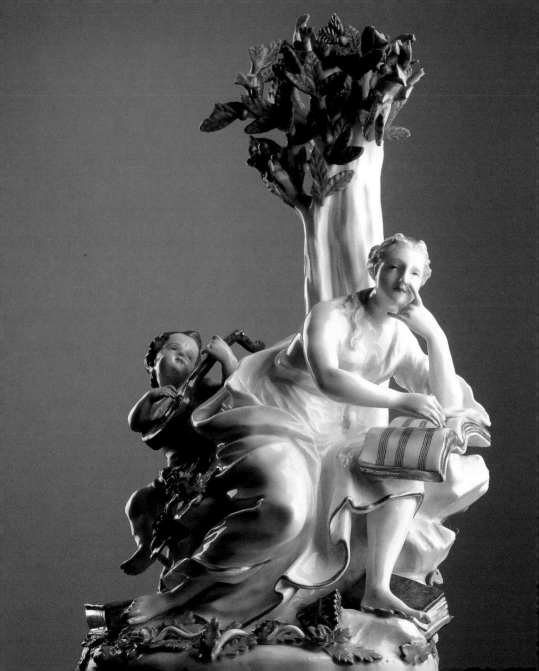

Calliope is conscious of her responsibility to the weightiest form of literary creativity. This is how the great ceramic artist Johann Kändler saw her: beautiful, austere, pensive—a figure preoccupied with thoughts and visions. She has little color except in her flushed cheeks and in her fair hair, which flows disregarded over her shoulders. She holds on her knee a great book of music manuscript; other huge tomes are placed to the right and left for reference; and a little putto, or angelic child, plays and dances quietly behind her. His wistful face suggests that he is dancing to rather plaintive music, a soft background for one for Calliope's meditations. In addition to being beautiful, this is a formidable lady, one worthy of advising an epic poet. The causal pipes of easy music lie spurned at her feet, and the flowers that seem to grow so naturally around her tree are, in fact, bound together by a cord. Calliope is organized, focused, the least casual of the sacred sisterhood.

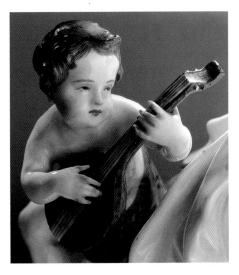

J. J. Kändler. *Calliope.* c. 1745. Porcelain, 11¾" (30 cm).
Private collection

Erato

*E*rato is the Muse of the lyric, the love song. One would imagine that today she works overtime, since love is still the theme of nearly every song that we hear. She is the Muse of the emotions, as Calliope is the Muse of the intellect, but it is the emotions transformed into poetry. When "burning Sappho loved and sung," [5] as Lord Byron described her, and when Byron himself poured out his love poetry, or William Wordsworth, or W. H. Auden, it was Erato who brought inspiration, sustaining them in the pain of love and leading them into its glories. Love is essentially free, and so Erato carries with her wild grapes, the symbol of passion. At her bare feet lies the tambourine. In her dance she will shake it, but with some measure of control. Freedom does not mean wantonness, which only serves the selfishness of false love. True love is wise in its abandon and looks not inward at itself, but outward at the beloved. This slender little Erato is French, but she is not from any of the important French factories: she is not from Sèvres, for example, or Valenciennes. She is not even original. Some small French firm copied her and did its best, using rich color, to make her worthy of Musedom. There are imperfections in this

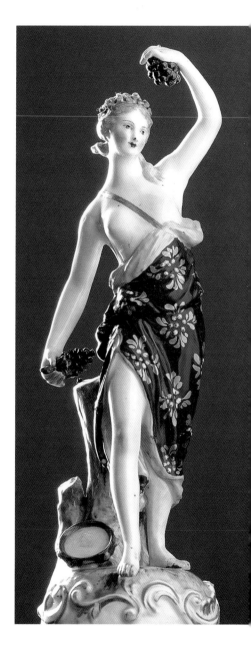

porcelain Erato, but I find them lovable. Her brown hair, for example, is meant to be flying loose as she whirls around in dance. The sculptor could not quite manage this, and one lock of hair sticks out stiffly, while her long blue robe, lustrous with golden flowers, wraps itself unconvincingly around a tree stump in the artist's effort to show rapid movement. But she does seem to move, quite enough for us to sense that she gravitates toward her poets. She does not approach smilingly. Love is too serious, perhaps too painful. Those whom she inspires will need the comfort of her dark grapes.

Urania

It sounds rather dull to describe Urania as the Muse of astronomy, even if we add that when, in the beginning, there were only three Muses, she (along with Calliope and Erato) was one of them. But this shows her significance: she inspires all who seek scientific wisdom. The heavens, so near and yet so tantalizingly far, were the first area of scientific endeavor. The very name "Urania" comes from the Greek word for heaven, and she carries as her symbol not what we think of as a globe, the earthly sphere, but a globe that shows the heavens and its stars. To make her role plain, this little Urania also holds a golden crescent, the man in the moon. We have all read about the extraordinary unexpectedness of scientific discovery, how accidents and even dreams have led to the finding of miraculous substances like penicillin and radium. An apple, we are told, fell on the head of Isaac Newton, and he was the first to understand the law of gravity. "Eureka" (I've got it) was said to be the triumphant cry of the ancient scholar Archimedes when he suddenly realized a new law of nature. All of these discoveries would have been the concern of Urania.

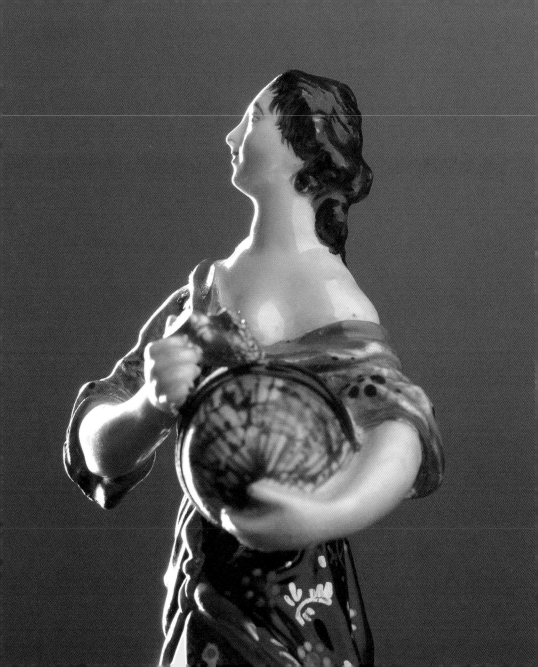

Right from the start, the Greeks believed science to be as creative as art and that only with the help of true inspiration would we come to know how our world and the heavens work.

This is a little English figure, made in the North country of England, in Derby. She is not magnificent like the Meissen ceramics from Germany, but in her own way I find her glorious. To begin with, she is overflowing with self-confidence, which is just what we need in this time of uncertainty. She is richly attired in green, pink, blue, orange, yellow, white, and purple, not to mention gold, which dominates her coloring. Her small neat head is tilted skyward with serene aplomb, not smiling but intent, in control, vigilant. We feel that the celestial globe and the amazed moon are safe in her delicate grasp.

Unknown artist. *Urania.*
Nineteenth century.
Porcelain, 4½" (11.5 cm).
Private collection

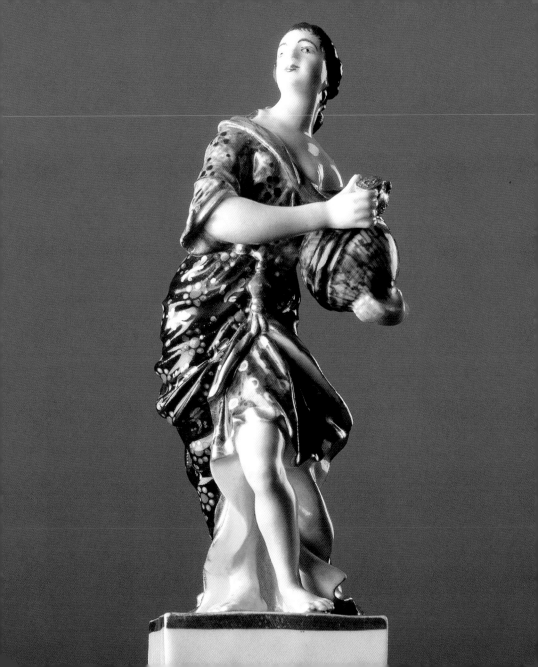

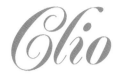

*C*lio is the Muse of history, a reminder of a faraway time when there were no novels (far less, magazines), and the most entertaining read available was a history book. Even for those of us skeptics who may secretly feel that all history is touched by fiction, a fascination remains. Clio inspired those who wanted to make sense of what happened, to discover the facts, first of all, and then set them down in a pattern. History

sounds more important than fiction, and there is no Muse of fiction as such. Clio may well stand for both. She is very conscious of history's claim to be truthful and therefore something that will last. She bears aloft the laurel wreath with which victors are crowned: only the historians can tell us who those victors really are. But history also needs to be known, to be

proclaimed, and so Clio also carries a golden trumpet. If the truth is not heard, it will be through no fault of her own. This is a gentle little Clio from Vienna, with a touch of Austrian sweetness about her. There are Clios perkier by far and more dominant (there is a delightful Chelsea Clio in the Victoria and Albert Museum), but something about this little face appeals to me. She is uncertain, with that big trumpet pressed against her thigh, and the wreath clutched tight, as if not willingly surrendered. She has a small, pursed mouth, too: a skeptical Clio, which is very much to my liking.

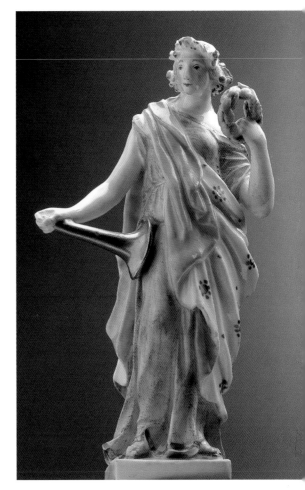

Unknown artist. *Clio.* c. 1765. Porcelain, 5¾" (14.5 cm). Private collection

Terpsichore

Terpsichore is the Muse sculptors feel most at ease with because she is doing something: she is the Muse of dance. We might call her the Muse of movement, of those athletic contests in which only an inspired player can score a goal or hit the ball just where the other players cannot reach it. She is not the Muse of predictable dance, which has its own rules, but of all the skilled improvisations in which a highly trained body can take delight. Great skaters, great marathon runners, great scorers at basketball or baseball or ice hockey: all of these athletes need Terpsichore. She does more than just dance. She sings while she dances, so ballet may interest her less than the impromptu song and dance of the old-fashioned music hall. Compared to the others, she is the most graceful of the Muses, and this is a small Meissen figure of the most refined elegance. Johann Kändler did fashion a Terpsichore, but that figure shows a vehement, impassioned dancer. This small version is by another Meissen artist, one of the Meyer family, whose figurines are always recognizable for their small heads.

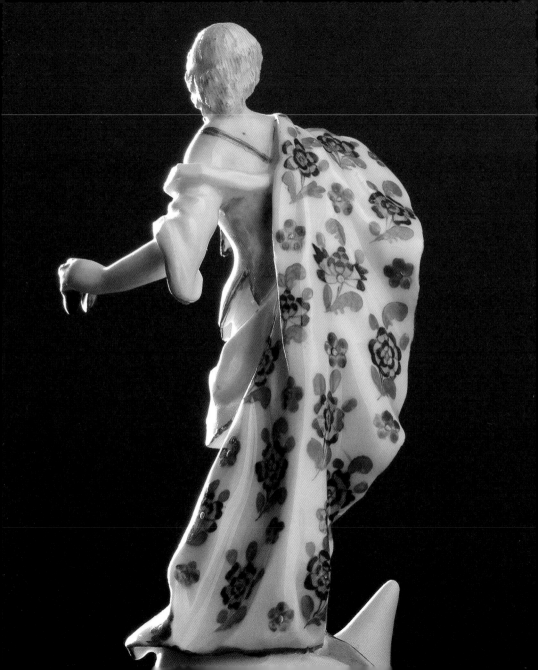

This Terpsichore drifts over the flowers, clapping her castanets, lost in the magic of her dance. Her pale robes float softly around her, but she seems conscious only of her own inner direction. She is clearly not performing for anybody's entertainment: this is a spiritual dance, almost a prayer. The only playful touch is the conical hat at her side. This is a jester's hat, though here it is a sober white. Still, its very presence reminds us that dance can become a wild gyration, a shouting, laughing thing, even if this figure seems unaware of this dramatic possibility. Her hair is tidily combed back, and the two little breasts that peep out of her bodice have a constraining tassel before them. Maybe we are meant to be reminded that dancing is also a cerebral undertaking, even if it is often swept into the emotion of Terpsichore's inspirational challenge.

Meissen artist, from the Meyer family.
Terpsichore (two views). c. 1830.
Porcelain, 4¾" (12 cm).
Private collection

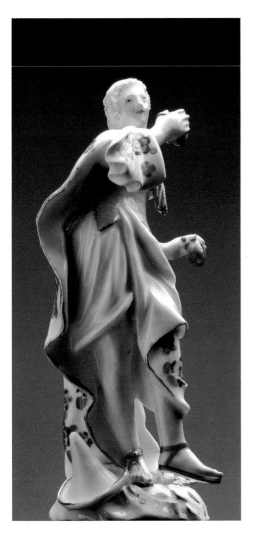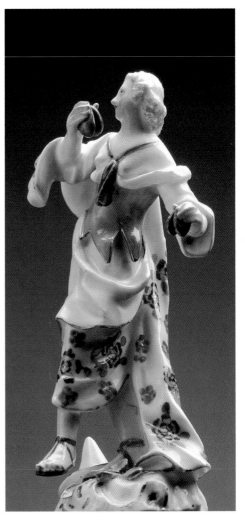

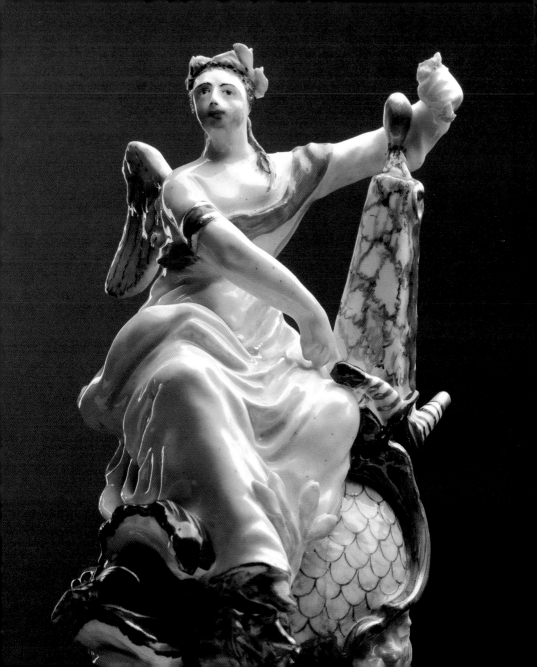

Melpomene

I am cheating a little when I call this Muse Melpomene, the Muse of tragedy. The dealer who owns this figurine thinks she is Polyhymnia, the Muse of sacred song, and one could also make a good case for saying that she is not a Muse at all, but a Victory. All the same, I think she is Melpomene and that she is winged because true tragedy is spiritual: loss of mere material possessions never truly broke a heart. She is surrounded by emblems of battle, since tragedy is basically a combat, which the best man rarely wins. But these emblems are rather exaggerated, since the tragedy here is a stage production. Hence we have all the props: helmet, shield, rolled-up banner under Melpomene's feet, memorial urn with flame and laurel wreath, and not one sword but two. There is

Unknown artist, possibly the Muses Modeler.
Melpomene. c. 1750–52. Porcelain, 7½" (19 cm).
Private collection

always a villain as well as a hero. Melpomene displays all the emblems of her drama with the utmost brio. She is a dashing figure who is not particularly alluring but full of self-confidence. Since most operas are tragic, these, too, fall to her guidance; indeed, her larger-than-life presence has a genuinely operatic feel to it. The Muse of tragedy cannot afford to let gloom overwhelm her: it is her duty to remember that sadness is an earthly emotion. On the mountain slopes where the Muses live, there is only joy. Of all the nine Muses, then, her task is the trickiest, involving a mental balancing act. Melpomene seems to have little trouble with this. She is English, created by the Bow factory, where the Muses were so popular that one artist, whose name was never recorded, was known as "the Muses Modeler." His style is characterized by a certain clumsiness in handling, and this is the most ungainly of the ethereal nine. Because of the solid, impressive, and queenly qualities of this Melpomene, however, we may still be able to gain pleasure from her inspirational form.

Thalia

While she is the largest, most elaborate, and most magnificent Muse figurine in this book, Thalia, the Muse of comedy, is the hardest Muse to understand. What strikes us immediately about this Thalia, one of Kändler's greatest achievements, is her strength. Comedy may center on laughter, but at base it is a tough coming-to-terms with the nature of life, combined with the grace not to take it too solemnly. There is a nakedness in comedy, and Thalia innocently displays the length of her beautiful body. Comedy faces truth without concealment. But there is also, paradoxically, elaborate and delightful concealment in comedy, a use of masks, or role-playing, a refusal to let the drabness of the ordinary become too overwhelming. They are smiling masks, and yet there is something frightening about them. When we play with other "faces," we are in a world of make-believe, a world that may have rules we do not fully grasp. All comedy takes risks, and the grinning masks hint at this. Thalia has a monkey, too, since much joking involves copying others, but with a humorous twist. Our distant cousin, the monkey, imitates what we

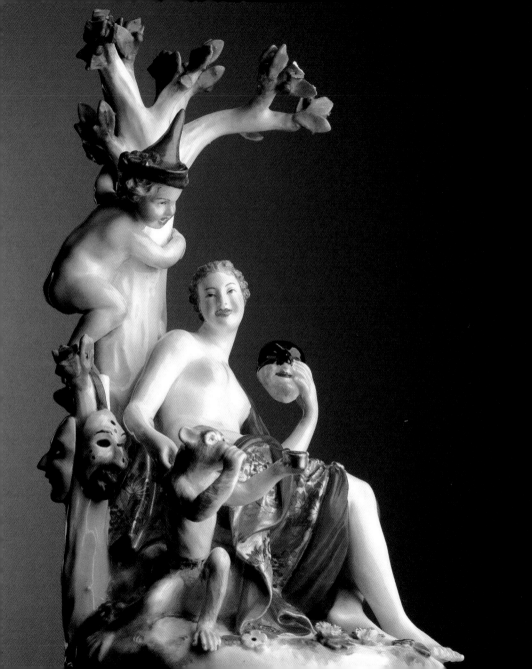

do and seem to be, and in making us laugh shows us our foolishness. This small monkey is inhaling snuff, that seventeenth-century preparation made of tobacco that is used as a stimulant. It was once believed that inhaling snuff would purge the bodily humors by making one sneeze. Sneezing is involuntary, fierce, comical. It is another form of that unsteady hand at the controls that Thalia understands and will help us to find funny rather than threatening. Her music comes from the putto above her, whose rosy mouth is wide with song. This Thalia is immensely in command of herself and her world: her hair is tight to her shapely head, the flowers before her feet blossom in meek rows, and her laughing face is radiant with a secret happiness. She so obviously enjoys life.

J. J. Kändler. *Thalia.* c. 1745.
Porcelain, 10⅝" (27 cm).
Private collection

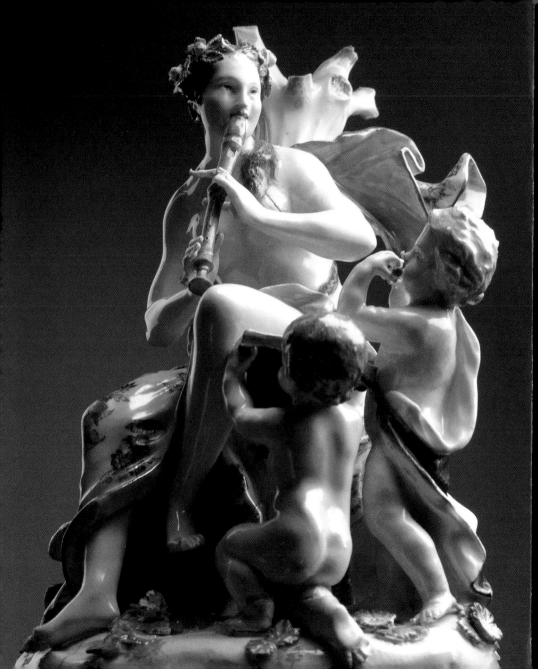

Euterpe

All of the Muses are musical, as stands to reason, and most have their own musical instruments. Polyhymnia is associated with a small portable organ, and even dancing Terpsichore claps her castanets. But music has its own specific Muse, Euterpe. If merely listening to great music can transcend into a mystical experience—and most of us would testify that there is nothing that so speaks to our deepest being—then what must it mean to compose music? How, we ponder (I nearly said *muse*), did Mozart know when to diminish his sound, when to swell it, when to combine chords, and when to isolate them? And how did he know so certainly what specific notes to choose, what patterns of melody to create? Of all the arts, it is most clear to us that music flows from inspiration. Kändler has fashioned a superbly inspirational Euterpe. Although she is sitting at ease on her flowery rock, her very garments, also flowered, stream into the breeze as the power of her music sweeps through her. Her long, strong legs are taut with concentration as she pauses, flute at the ready. The flute was a controversial instrument in Greek and Roman mythology. Minerva, the Roman goddess of wisdom, invented it and

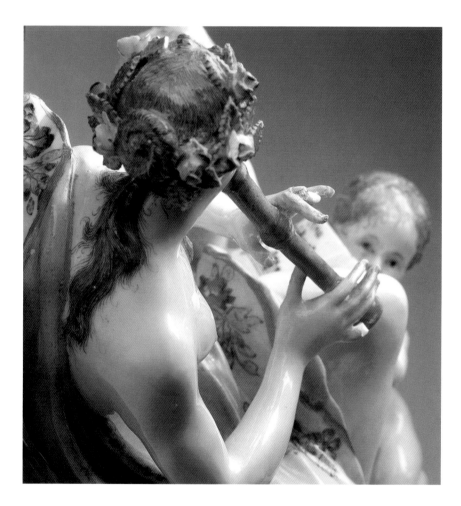

then threw it away with a curse when she heard the other gods laughing at her puffing cheeks. The satyrs and fauns picked it up, and it became a wild and primitive object, passionate rather than spiritual. Euterpe rescued it and taught others to use it, too, for the purest musical purpose. Kändler sees her as teaching, or at least sharing, her art. The little children are as attentive to the beauty of the notes as she is herself. There is a dreamy smile on her rosy face, her black locks are escaping from the bun in which she has tried to confine them, and a long, soft tress falls over her breast. Euterpe, as befits the Muse of music, is both lost in her art and totally in command of her powers.

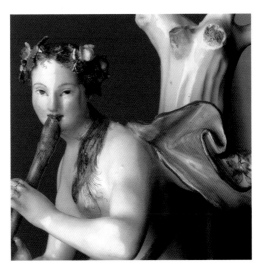

J. J. Kändler. *Euterpe.* c. 1745.
Porcelain, 8⅝" (22 cm).
Private collection

Polyhymnia

nspiration has always been a theological term, and the nearest we come to a Muse of religion in Greek mythology is Polyhymnia. She was the Muse who inspired sacred song, that most constant and fundamental element in worship. Her task was far from easy. Today we call "sacred songs" hymns, and, of course, her name means "hymns abundant." But it was a nineteenth-century preacher (and hymnbook publisher) who complained that the devil seemed to have the best tunes! Great hymns are rare and precious, as they, too, must incorporate melodies and provide, even more importantly, the right words of devotion. What we sing to God matters more than how we sing it, yet these two elements cannot be disentangled. Polyhymnia needs all her inspirational powers to breathe into people of faith and musical skill the words and the melodies that will lift their hearts up to God. Kändler, that great artist, was equal to the task. His Polyhymnia is a figure of unmistakable authority, for all her gentleness.

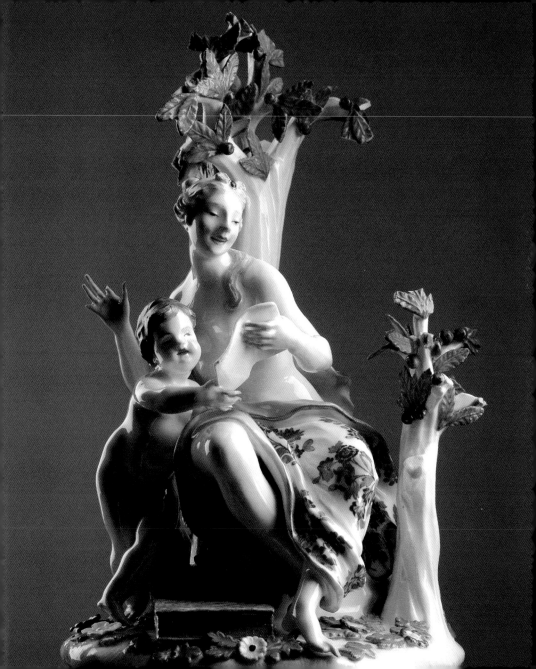

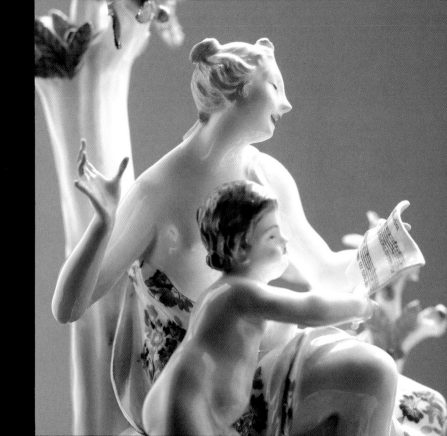

At her feet, amid the flowers, lies a large book, leather-bound and with gilt edges, uncannily reminiscent of a Bible! Why not, Kändler might have asked, since there is no time with God? Her hair is a faint auburn, wreathed into an intricate pattern and decorated with a single ruby: she is both simple and complex. Her head is slightly bent, as in prayer, but when we look into that lovely face, we see that she is simultaneously smiling and singing, no easy feat as we know from the contortions of the opera. Kändler makes her wholly believable. She is smiling to herself, lost in the happiness of singing what she believes. Joining with her in prayer is an acolyte. He holds the music with her and, with lips just barely parted, hums along with his teacher. Polyhymnia is serene, but she is not staid. Religion needs no cover-up or false modesty. Nor is Polyhymnia dull. No Muse is more alive, more vibrant with eagerness, than she who inspires songs of praise to her divinity.

J. J. Kändler. *Polyhymnia.* c. 1745.
Porcelain, 10¼" (26 cm).
Private collection

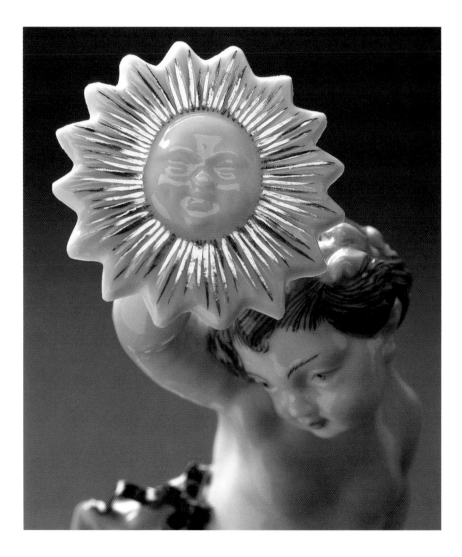

Apollo

At Upton House, in Oxfordshire, there is a complete set of Chelsea Muses. They fill a glass cabinet, nine handsome eighteenth-century females, with swanlike necks and faces shyly bent. Radiant in their midst, confrontational and glorious, stands their leader, the splendid male Apollo. Granted, he is not a Muse, but he is something more, Apollo Musagetes, their center, to whom the nine are essentially a chorus. Golden Apollo holds his lyre, indicating his right to be musician par excellence. He is god of poetry, of intellect, and of song and fits these activities around his real role, which is to be the sun god. While not desiring to reduce his stature, I cannot refrain from using, as my illustration, the work of the greatest of all ceramic artists, Bustelli. This mysterious figure, who died young in the service of the Nymphenburg factory, was inspired to take his copy of Ovid and to sculpt all of the gods described therein, but as children. His Apollo, then, is no ineffable grandee, but a baby sweetly peeping out at us from beneath his emblematic sunflower. There was always a loving relationship between Apollo and the sunflower. This is

the flower that turns at all times to face the sun. Bustelli's baby god repays the affection: the flower's center is replaced with the sun's face. Small Apollo also holds a lyre, but modestly, as befits youth. And far from standing grandly in a focal position, he seems to be dancing. His garment floats out on the wind of his movement, and one chubby leg is about to be raised. He is still, by destiny, leader of the Muses, but a leader who will move among them gracefully and not always in majestic isolation at their head. If inspiration is to shine on us from every direction, or at least from nine sides, there is a witty aptness in having all this light and beauty summarized in the sun god and for us to find him as endearing as his lovely companions.

Unknown artist. *Apollo*
(copy from an original mold
by Franz Anton Bustelli).
Twentieth century. Porcelain,
5⅛" (13 cm).
Private collection

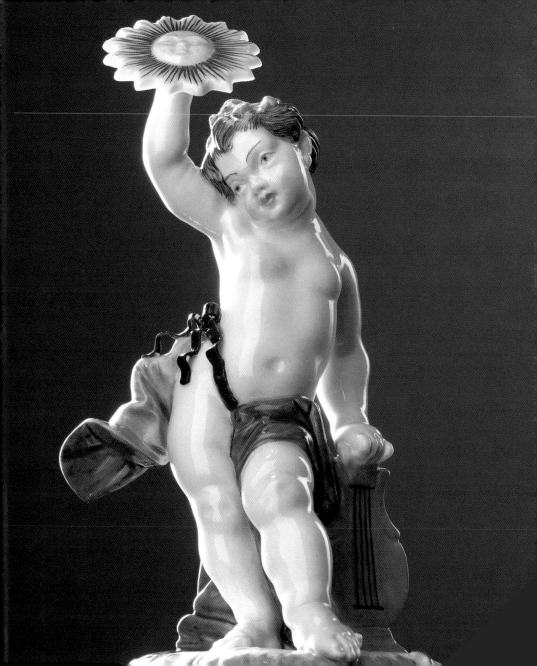

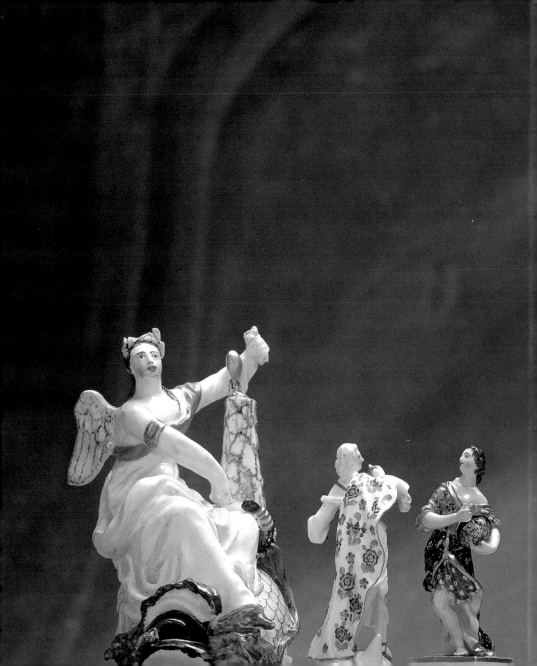

Notes 🐛

1. "Ode to a Nightingale," lines 13-14.
2. *Henry V*, prologue, line 1.
3. *Paradise Lost*, book 1, line 6.
4. *A Midsummer Night's Dream*, act 3, scene 2, line 323.
5. *Don Juan*, canto 3, stanza 86, line 1.

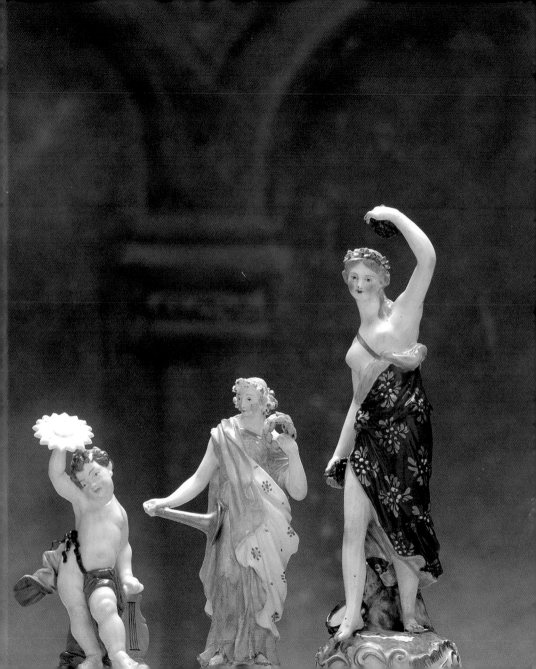